MW00781576

SCAREDY
CATS

RUNNING PRESS
PHILADELPHIA · LONDON

Library of Congress Control Number: 2008922942
ISBN 978-0-7624-3423-7

Running Press Book Publishers
2300 Chestnut Street
Philadelphia, PA 19103-4371

Visit us on the web!
www.runningpress.com

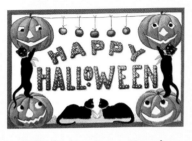

Jack o' Lanterns. Vampires.
Witches on broomsticks.
Zombies. Ghosts & Ghouls.
Menacing mummies. Scarecrows.

3

Sinister spiders. What is missing from this witches' brew of harrowing Halloween icons? The black cat, of course! But the black cats aren't the only kitties that are creepy . . . especially around Halloween time.

This spooktacular little volume brings together an amusing collection of frightening—and

frightened-looking!—felines that will scare you silly! Inside you will find cats casting spells, lurking within shadows, carving frightening faces out of pumpkins, and just simply creeping around on stealthy feet with an unknown agenda that lies beyond that cute and cuddly exterior. Don't let these kitties

6

fool you—you do *not* want these cats to cross your path!

The hair-raising photographs are accompanied by humorous, terror-ific text that will wickedly charm you with the spirit of the season. The full moon is out, the jack o' lanterns are lit, and *Scaredy Cats* are ready to pounce!

8

LET'S GET
THIS PARTY
STARTED.

Let's do the Monster Mash.

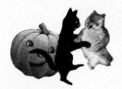

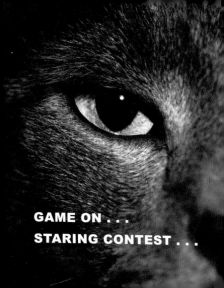

GAME ON . . .

STARING CONTEST . . .

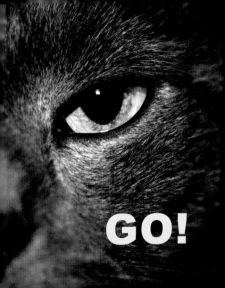

GO!

Beware!

These claws are not just for climbing.

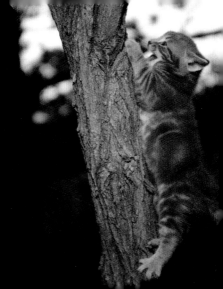

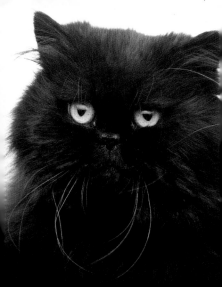

Don't cross me if you know what's good for you.

You call

this

creepy?

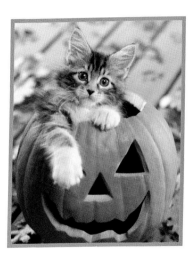

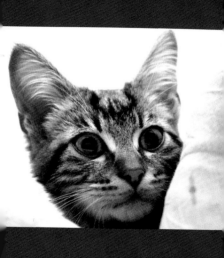

I know it's a costume party, but seriously!

**Dark
shadows
fade into
my favorite
part of
the day. . .**

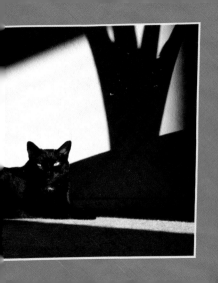

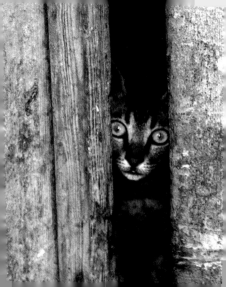

Welcome to my lair.

Step AWAY from the pumpkin.

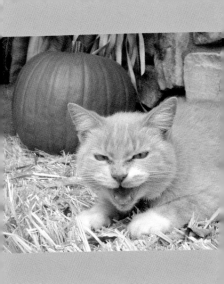

You don't want to talk to me before I've had my morn- ing witches' brew.

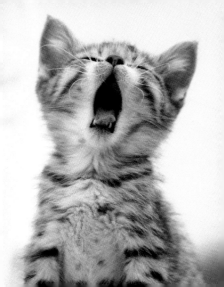

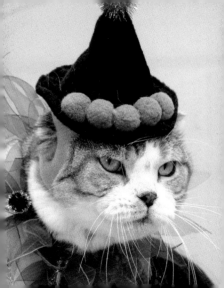

This isn't the
scary costume
I had in mind.

The zombies are coming to get me!

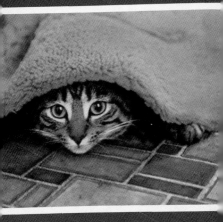

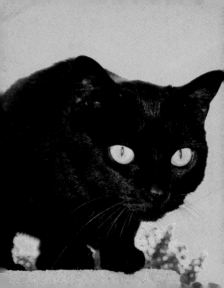

Did someone say "Full moon"?

Searching for the evil that lurks beyond...

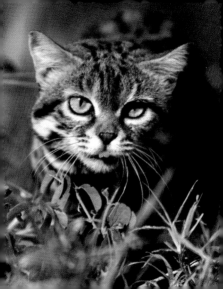

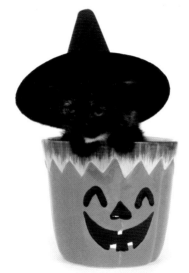

Double, double, toil and trouble . . .

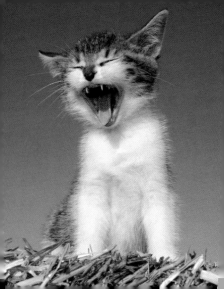

THEY TOLD ME
THERE WOULD BE
SCARECROWS.

I am a creature
of the night!

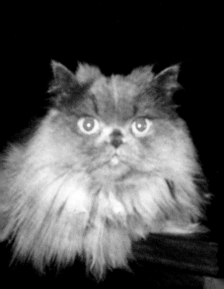

You were great in
that Hitchcock film.

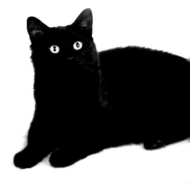

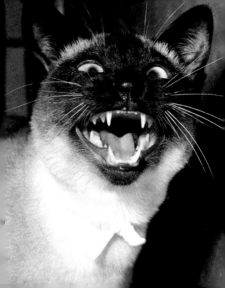

That's fang-tastic!

Are you up for a hair-raising experience?

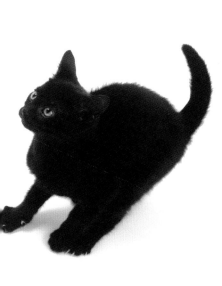

Cat-o-lanterns!

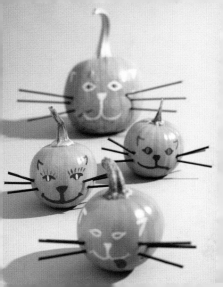

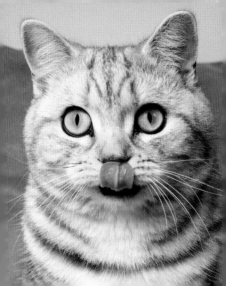

YUM, CANDY!

Those ghouls won't find me up here.

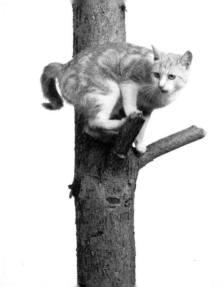

You look like
you just
saw a ghost!

I could get there faster
on my broomstick.

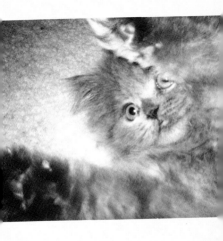

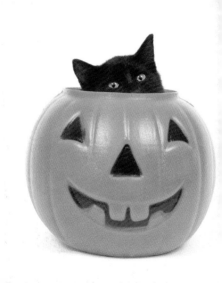

Trick . . .
or treat?

Wanna go
hang out in a
graveyard?

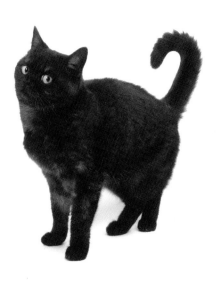

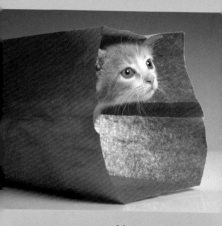

Are the ghosts and goblins gone yet?

I just can't watch this horror anymore!

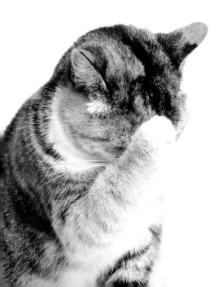

Do you want to go bobbing for mice?

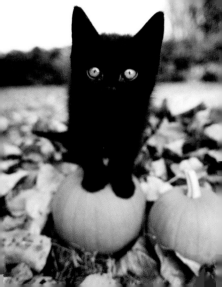

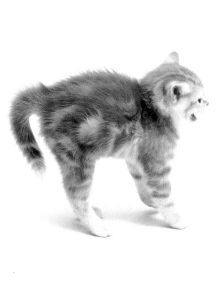

SCARED
SILLY!

WHO ARE YOU CALLING A SCAREDY CAT?

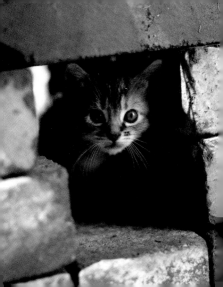

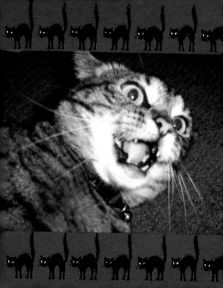

PEEK -A- BOO!

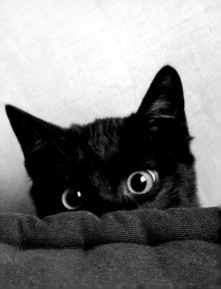

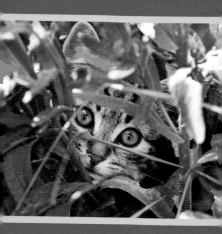

Which way to the pumpkin patch?

Let's carve out some FEAR.

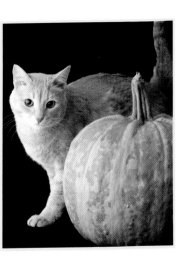

Look into my eyes,

you're getting sleepy . . .

I think black cats get a
bad rap on October 31st.

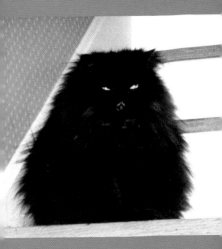

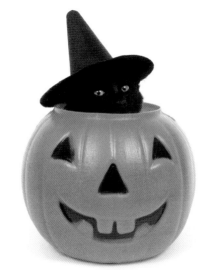

Would you like me to cast a spell on you?

Let's go watch some horror flicks.

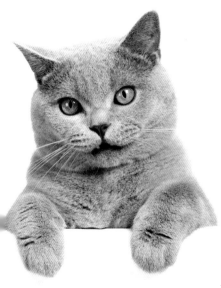

Just hangin'
out until
Halloween.

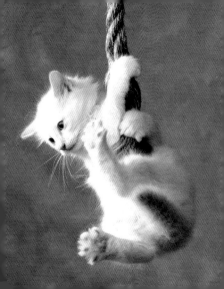

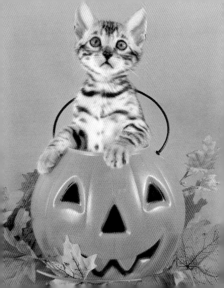

YOU ARE WHAT YOU EAT.

Look away from the evil!

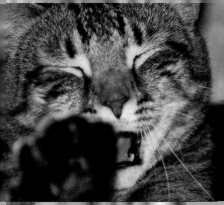

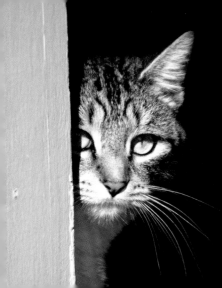

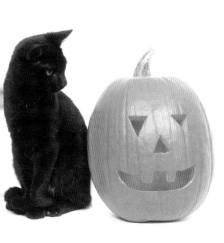

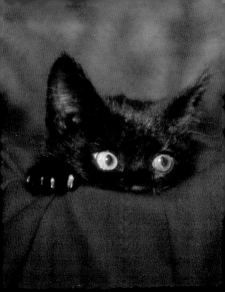

I'd give that horror film one paw up.

EVIL'S a
BREWIN'.

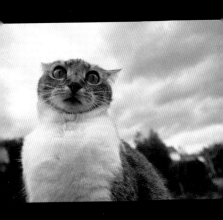

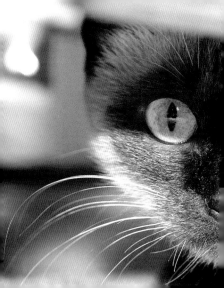

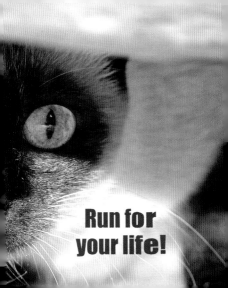

Run for your life!

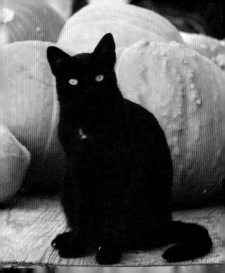

Do you

know any

black magic?

No, I'm not a werewolf.

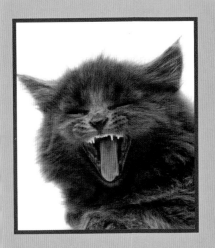

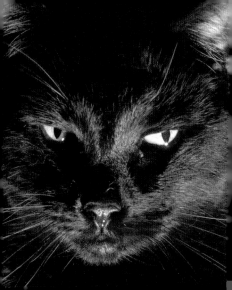

Don't even THINK about it.

WHAT, NO
CAN DY
LEFT FOR
ME?

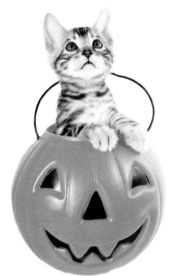

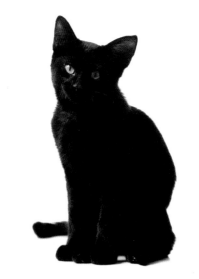

Me, evil? Never.

I think we
could use some
eerie music
right about now.

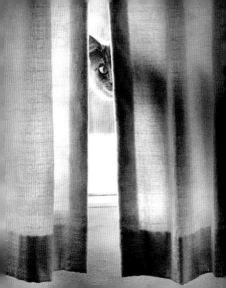

First prize for the
self-portrait
pumpkin carving
contest goes
to . . . me!

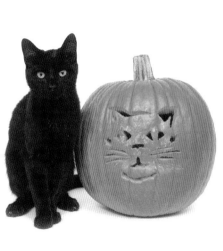

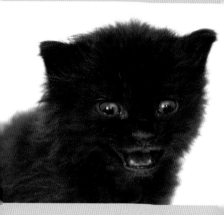

WHAT DO YOU MEAN THE CANDY IS ALL GONE?

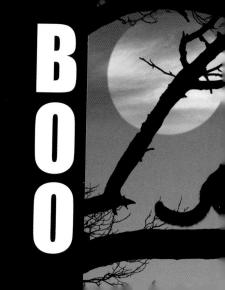

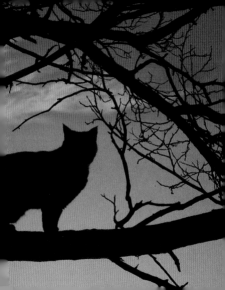

Picture Credits:

Front cover photograph: ©iStockphoto.com/Peeter Viisimaa
Front cover illustration and pp. 1, 3, 11, 28, 35, 42, 50, 58,
 62, 72, 79, 88, 107, 111, 116, 121 & 128: Old-Time
 Halloween Illustrations CD-Rom and Book, © 2007 by
 Dover Publications, Inc.
Back cover photograph: ©Burazin/Iconica/gettyimages
Endpapers: ©Lew Robertson/StockFood Creative/getty
 images
pp. 26, 41, 71, 74–75, 108 & 115: Vintage Holiday Cuts
 CD-Rom and Book, © 2007 Dover Publications, Inc.
p. 4: ©Wayne Eastep/Photographer's Choice/gettyimages
pp. 8– 9: ©iStockphoto.com/Tony Campbell
p. 10: ©Mark Andersen/Rubberball Productions/getty
 images
pp. 12–13: ©iStockphoto.com/Eric Gevaert
p. 15: ©Purestock/gettyimages
p. 16: ©Dave King/Dorling Kindersley/gettyimages

This book has been bound using
handcraft methods and
Smyth-sewn to ensure durability.

The dust jacket and interior were
designed by Corinda Cook.

Photo research by Susan Oyama.

The text was written
by Jennifer Leczkowski
and Corinda Cook.